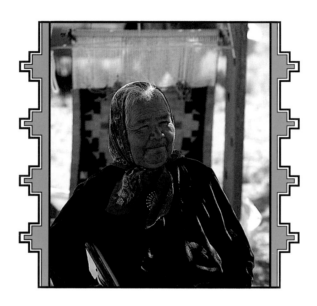

Katie Henio
NAVAJO SHEEPHERDER

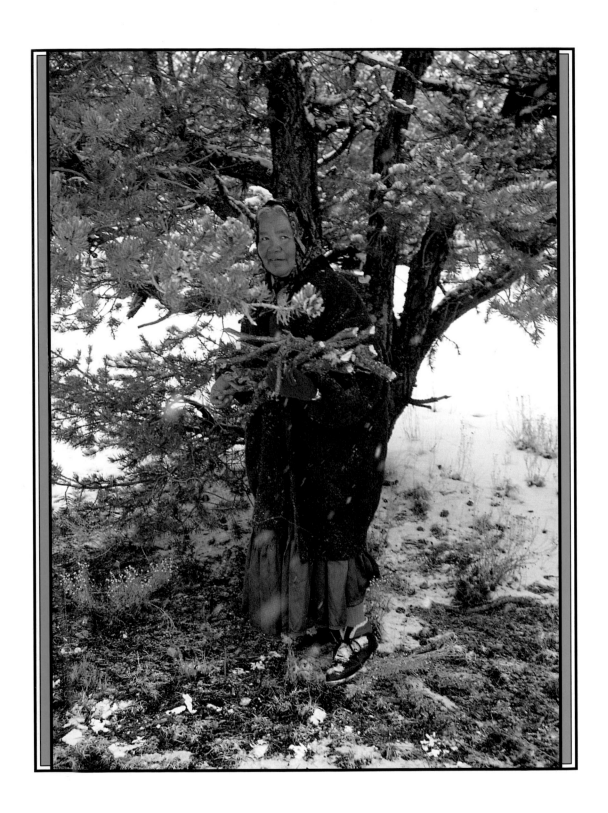

Katie Henio
NAVAJO SHEEPHERDER

by Peggy Thomson

PHOTOGRAPHS BY
Paul Conklin

COBBLEHILL BOOKS / Dutton
New York

Library of Congress Cataloging-in-Publication Data
Thomson, Peggy.
 Katie Henio, Navajo sheepherder / Peggy Thomson ; photographs
by Paul Conklin.
 p. cm.
 ISBN 0-525-65160-8
 1. Henio, Katie—Juvenile literature. 2. Navajo Indians—
Biography—Juvenile literature. 3. Navajo Indians—Social life and
customs—Juvenile literature. [1. Henio, Katie. 2. Navajo
Indians—Biography. 3. Indians of North America—Biography.
4. Women—Biography. 5. Navajo Indians—Social life and customs.
6. Indians of North America—Social life and customs.] I. Conklin,
Paul, ill. II. Title. III. Title: Katie Henio.
E99.N3H457 1994 973′.04972—dc20 93-40430 CIP AC

Published in the United States by Cobblehill Books,
an affiliate of Dutton Children's Books,
a division of Penguin Books USA Inc.
375 Hudson Street, New York, NY 10014

Designed by Charlotte Staub
Printed in Hong Kong First Edition
10 9 8 7 6 5 4 3 2 1

FOR

Katie Henio's daughter Sara and son Sam who took us about
in a family convoy of trucks, translating Katie's Navajo
to English for us and our English to Navajo for
her, stopping often to laugh and to
add comments of their own

Katie's grandson Dwayne, a bilingual boy, who gladly
tells tales on an admired grandmother

All the members of Katie's large family, who
tease her and honor her

Her sheepherding and weaving friends, especially
Annie Pino and Lorraine Wayne, who
never tell her to sell her sheep
and live at home

Yin-May Lee, organizer for the Ramah Navajo Weavers
Association, whose work is to make Katie Henio's
life a possibility for future generations

Katie Henio herself—sheepherder, weaver,
mother, leader, healer, cook, teacher,
a stubborn and spirited,
spiritual woman

The lucky flock, including
Burnt Woman

CONTENTS

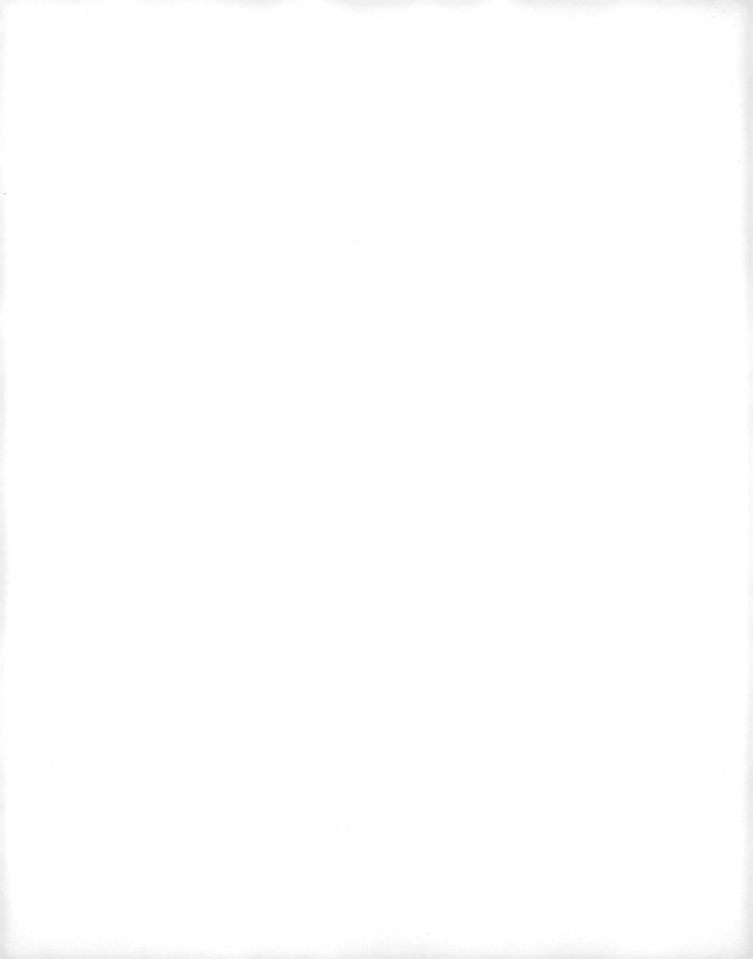

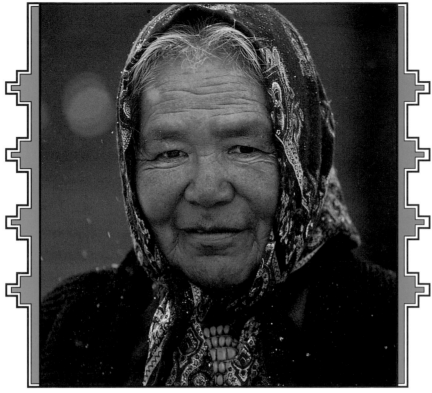
Katie Henio

INTRODUCTION

Katie Henio is happiest outdoors—driving her sheep across the rough grazing land or sitting at her loom in the open-air shade house. Or she's out in the woods and canyons collecting the plants she needs for her dyes and her medicines.

These days she is sometimes in a new place, also outside. She's on the grass Mall outside the Smithsonian Institution in Washington, D.C., where she tends sheep and weaves and grinds her plants just as she does at home in New Mexico. But here in Washington, thousands of people watch her.

As part of the Festival of American Folklife, she does her everyday things, while her son Sam tells her story in the English language she does not speak.

1

Katie Henio and her flock

Katie Henio feels awed that people want to know about her, a Navajo great-grandmother who never had a day of school.

She listens as her son tells how she lives on a small reservation—1,000 square miles, 2,500 people, 5,000 sheep—in west central New Mexico. Its name: Ramah Navajo, where the "wild onion" Navajos live.

He tells how she has been out among the flocks since earliest childhood and is so still, in sunshine and harsh weather. The land is harsh too—dry and studded with sharp black lava rocks. And she must ever be alert to sudden danger. Now her flock numbers 150 animals—sheep and some goats—and she knows every one of them as individuals. She bosses them

and enjoys them, keeps them on the move toward fresh sources of food. She protects them fiercely. Their wool she weaves into the thick rugs and blankets from the Navajo patterns in her head and in her heart.

To Katie Henio, listening as her son speaks, it's kind of a joke that crowds of people wish to hear all this. They wish to see how she ropes a running sheep and shears it and prepares its shaggy coat for spinning into yarn. They watch as she sits on the ground, weaving. Strangers even wish to see how she makes her frybread and her mush. She wonders, from such glimpses, will strangers understand? A life out under the sky with sheep, rocks, plants—just as her ancestors knew it—is a life lived in beauty. To her, it's her happiness. There are Navajo words, *iłhá hooshǫǫłii*, that tell of beauty and happiness and something more, something spiritual. Harmony perhaps. Her life—with sheep, rocks, plants, sky, and the wool for her hands to work with—is harmonious.

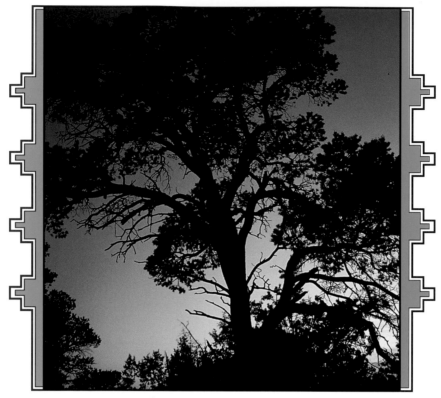

Early morning at the sheep camp

FIRST LIGHT

At sheep camp in New Mexico it's early morning, the time Katie Henio calls "first light," though even out beyond the far red-rock mesas, there's not a glimmer in the sky, not yet. There's not a sound from the sheep either, not a sound she'd hear above the crackling of her little fire. Katie Henio has slept well on her pile of blankets. She is facing east to receive the blessings of her holy spirits. She'll spend the new day out under clear skies with her flock of sheep.

In the dark, a quiet Katie Henio sips her coffee. She eats her breakfast of bread and jerky. The dogs are up, and soon she will saddle her horse, Dakota. Now it is time to set out grain for the sheep. At the brush corral, where pileups of branches fence them in, the sheep turn her way. They

scramble toward the gate to greet her, breaking the silence with their deep-throated bawling, a few voices at first, then a chorus. The sheep, and the goats, too, know their leader.

Now the sun washes the vast scrubby grassland in a pale light. Even on a June morning, the air is brisk. The animals scatter, and through the moving flock, the lambs dash out and back again on crazy side trips. They bump against the ewes, snatching swigs of milk.

From her horse, Katie Henio drives the sheep, keeping them headed in the right direction. She knows they'll reach the water hole by mid-morning. By noon, for the first time in ten days, she'll be home, where four generations of her family live in houses all in a row on family land. At home there's a corral with rail fences to pen her sheep. There's a big shade house that serves as the families' outdoor kitchen, as their gathering place, and as the work space where Katie Henio does her weaving with the wool from her sheep.

For a few days at home, Katie Henio will get on with her shearing and the many other wool-work activities. She'll catch up on family news and

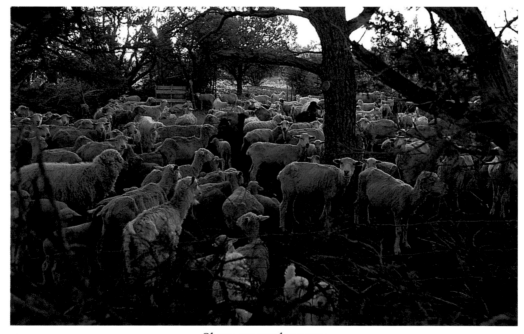

Sheep are ready to run.

5

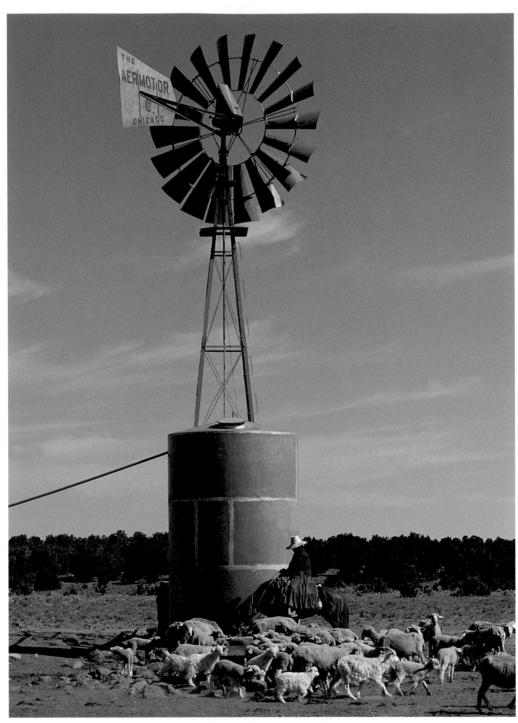

The flock gets a drink.

Four generations of the family

be part of the friendly hugs and commotion, though even now, heading homeward, she knows she will miss her camp life too. She'll miss the early mornings outdoors alone with her animals.

This day the sheep won't settle. They keep her on the run. They're playing, and so are the dogs. It's the breeze, Katie Henio knows, stirring them up. It blows her scarf, her hair, the edges of her saddle blankets, her full skirt. It's blowing her horse's mane and tail and bending the heads of tall flowers. So far it's not a real blow, not the kind that sets the sheep moaning, just enough to make them restless.

On a still day the sheep eat steadily, on the move, and then, nicely full, they settle. That's when Katie Henio sits on the ground with her balls of wool and her spindle—to spin and dream in the sunlight while her horse grazes.

Katie Henio calls to the dogs as she works. She talks to her horse. The flock has had its drink, and the horse has had enough grass. She tells him so. She tells Dakota he should lift up his head now and be lively. He should watch the goats. They're slipping off to the trees. Watch Burnt Woman too! With her white woolly body and her burnt-toast face, she's the troublemaker sheep, always. And she's off toward the trees with her lamb. She'll go anywhere, leading the rest. But not this time!

There are ditches and a road-under-construction to contend with and trees on two sides. The horse has put on a burst of speed and is making fast turns, kicking up dust. Katie Henio is swishing her skinny switch, calling "shóósh" and "shéé," driving the animals forward where she wants them. The animals are noisy, some bawling, some belching, goats rattling out rusty *drrrrrs*. Hooves clatter against the sharp rocks.

All her animals are through a gate into a fenced pasture—home and safe—but five of them have escaped into a cornfield and, shooing them, she yells her "swear" words that say, "Bear! Coyote!"

Just beyond, a welcome plume of smoke rises from the open-air shade house with its roof of branches. Someone is cooking. At the family houses across the way, doors are opening. Welcome home, Grandma!

In all of her flock, Burnt Woman is notorious for being an escape artist.

8

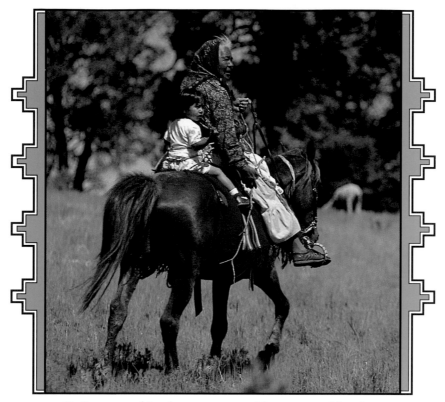

*Katie approaching home pasture with great-granddaughter
Shoogi riding behind her*

FAMILIAR THINGS

MY HORSE

"My horse, Dakota, really belonged to my son Nathaniel, but Dakota was too lazy for rodeo work, so Nathaniel gave him to my grandson Dwayne. And Dwayne lets me use him. I talk to Dakota and I've taught him how to herd.

"Dakota sometimes doesn't want to work. And I get mad at him. He slips away too. Two nights ago I'd hobbled him with his Bluebird flour sack. I'd tied it around his front ankles, to keep him from wandering too

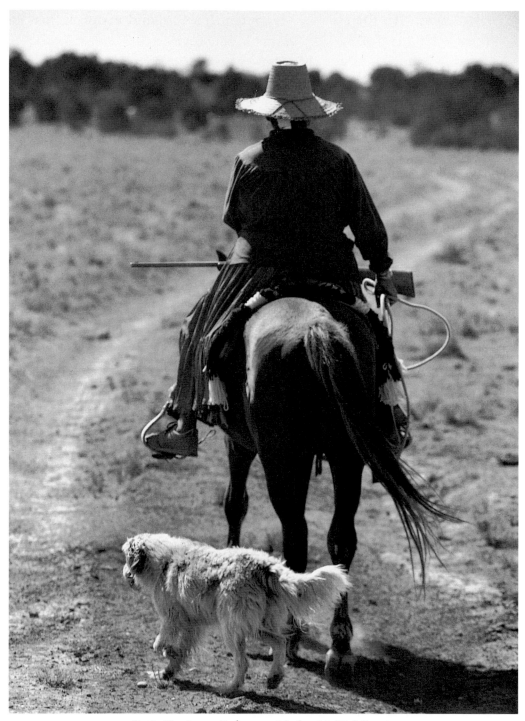

Katie Henio on Dakota, with dog Ma'ii following

far from camp. It's the sack he wears daytimes around his neck, just so I'll know where it is. And I'd tied his halter rope to a tree. But he broke off the branch and wandered off into the woods. He was hard to see, because he'd got his rope tangled up with the hobble and his head was pulled way down low.

"Dakota needs to wear good steel shoes because of all the outcrops of rock here on the ground. The lava rocks are really sharp. They're hard on hooves.

"The saddle isn't anything special, but it's comfortable for me. I got it fifty years ago at a pawn shop. And I hang bags of my stuff from it—lunch, my radio, my big knife, wool, and my spindle. One of the saddle blankets is a Pendleton, wool, the other one is Mexican. I got them from the trading post. I use Navajo stirrups. They're steel circles, wrapped in leather."

MY GUN

"My husband bought my gun for me forty years ago in Gallup. It's a .22 rifle and a good one. I leave it at camp unless I think coyotes are really near. Then I carry it across my saddle."

MY DOGS

"I call my lead dog Ma'ii (ma EEH). She's the best worker. She's a hero, injured in combat by a coyote. The coyote got into the flock, and it probably didn't see her because she's the color of the sheep. This small dog attacked the coyote and ran it off, but she's been kind of lame in the rear legs ever since.

"All the dogs know how to herd and to guard, but they forget sometimes. And they run off, chasing rabbits. Sometimes before morning they run from camp to howl with the coyotes. At camp Ma'ii sleeps in front of the gate to the brush corral, and the other four dogs sleep all around the edges. She only goes out with me."

MY TRUCK

"I started driving when I was fifteen, and I have my own truck. But with thirteen trucks in the family, I usually catch a ride to town with one of my children. Navajo trucks always have a lot of mileage on them. In this open land here we depend on our trucks. We include them in our prayers. Not just living things but trucks, too, are part of the harmony of life."

MY FRYING PAN

"Navajo frybread cooked outdoors in my old black iron pan is the best food there is. When I'm away from home, I miss it."

Katie Henio's truck

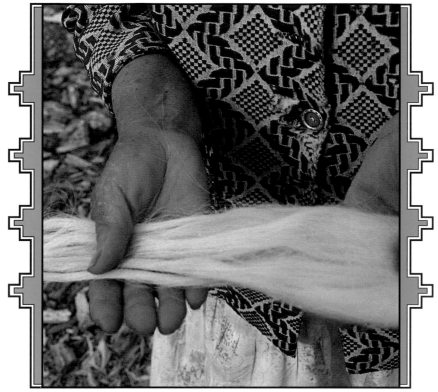

Churro wool is long, sometimes eighteen inches.

HAIRCUTS

The work of shearing Katie Henio's flock starts at the end of May, and it continues into mid-June. Not much later than that, for the sheep need to grow a thick coat in time for the winter's cold. Now, on a June afternoon in from the fields, Spotted Face gets her haircut. She's one of the last in the flock, and it's her turn.

When Katie Henio enters the home corral, the sheep are wary and start moving. They circle fast. Children have come too, and eight-year-old-grandson Mario, with orders to "catch the spotted one," makes a pass at a shaggy sheep with black around the ears. He misses, runs and lunges again, snagging a tail. This time his grandmother has got a grip too. She

13

has latched onto handsful of wool at the neck. And with hauling by her and shoving by him, Spotted Face lands on the open shed floor, more or less in her sheepherder's lap.

Belly fur gets clipped first—short curly stuff of less value than the rest. That done and set aside, Katie Henio ties three kicking legs together and begins to remove her sheep's fleece all in one handsome thick piece. From the area of the now-pink belly, her clippers click-clack, up the chest, up through the dirtiest wool, matted with dust, with leaves, burrs, seeds, and twiggy bits.

Katie Henio draws Spotted Face up close to her body, leaning an arm across the sheep's neck to immobilize the head. The wool is thick. But her blades are sharp. She sharpens them herself on a stone. And she works

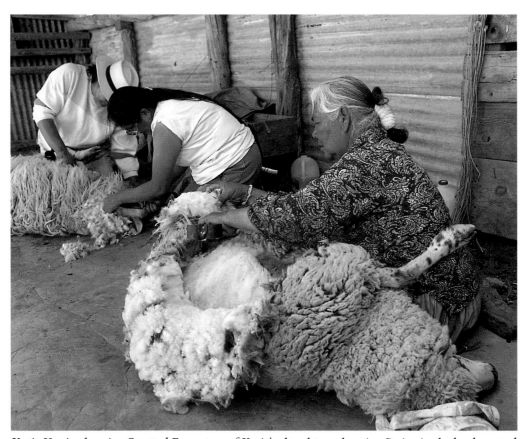

Katie Henio shearing Spotted Face; two of Katie's daughters shearing Daisy in the background.

with a sure grip, cutting always as close to the skin as possible without nicking it.

She concentrates. "When you shear you have to keep your mind clear and open, you have to be patient. If your mind is troubled, if you are thinking of other things, there's no way you can do it."

In the shearing shed, along with the sound of the clippers, there are soft words from Katie Henio spoken to her sheep, soft *baaas* from Spotted Face, spoken into Katie's hip. "My sheep know me," she says. "They'd be more excitable with someone else. And Spotted Face is a calm animal anyway. It's the third time I've shorn her."

All the same, this calm animal is delivering a few kicks until, at the time of the big flipover, the fourth leg is tied with the rest. In any case the clippers have a strap, around Katie Henio's wrist, so that a kick won't send the sharp tool flying.

Working now from head to tail along the sheep's back, shearer Katie Henio shifts from time to time to clip from a standing position. Spotted Face shifts too, even once twisting her head to nestle it onto a pillow of her own wool.

There's a final snip. And Spotted Face, now free of her coat, is released to run, jumping, back into the flock. She's a bit crazy from her experience, and her companions frisk and jump, too, inspecting the new look of her.

Katie Henio holds up the bulky coat for a gentle shake. It's still moist and heavy, perhaps eight pounds. She can sell the wool. But her mind is set on saving it. One fleece such as this (with two or three months of work) will make up into a good-sized rug, big as a tabletop. Weaving with the wool from Spotted Face will be special.

Katie Henio's only regret is that age has slowed her. She used to shear fifteen sheep in a morning and as many again in the afternoon. Now fifteen in a day is about her limit.

As it is, she rests a bit in the shade of the shed, picking at a handful of wool, removing seeds from it and wisps of hay, pulling at the fibers to bring them into line, even stretching, twisting, pulling—to make a loose bit of rope. She's almost spinning with her fingers, playing at the job she wants to start—very soon.

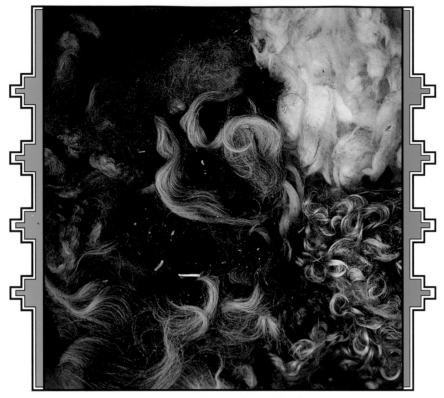

Navajo wool in traditional colors

NAVAJO CHURROS

Shaggy Spotted Face and Daisy are Navajo churro sheep, the breed of sheep most highly prized by the Navajos. They're long-legged and strong—good scramblers over rough ground. Churros give birth easily and are reasonably good parents. Especially important to someone like Katie Henio—their thick coats of very long, not very greasy, wool are ideal for weaving. Some churros have curly horns; a few even have four horns.

Navajos like to say the sheep were given to them by Changing Woman, their creator spirit, and the knowledge of weaving by Spider Woman. The sheep were given in four colors—in white, gray, red-brown, black. Four colors, four sacred mountains at the edges of their land—four is a special

16

number to the Navajos. They say that at the four sacred mountains Mother Earth touches her hands and feet to the hands and feet of Father Sky.

Some Navajos also say that churro sheep came from Spain some five hundred years ago and that Navajos from the North took animals from the Spaniards, and that they learned to weave from their neighbors, the Pueblo Indians. Katie Henio says only that the Navajos traded skills and yarns with the neighbors. They became devoted raisers of sheep. And sheep came to be the center of their lives, so much so that a Navajo name for sheep, *bee'iin'á át'é*, means, "that by which we live."

Katie Henio and the weavers like her on her reservation are working to increase the number of these sacred animals. The community, with five thousand sheep in all, has more than 300 churros, and Katie is proud to have twelve of them in her flock. She wears a little braided wool bracelet made from the wool of Spotted Face, a favorite Navajo churro.

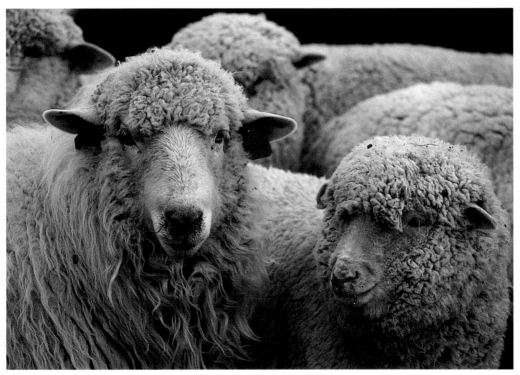

Long-haired churro, left, the traditional Navajo sheep, and Rambouillet sheep, right (called "rambly" by Katie's family)

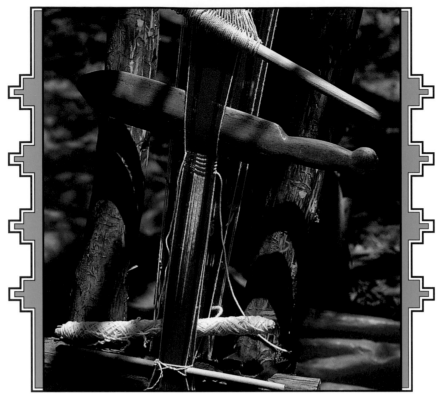

Ceremonial sash on loom

DYES

As a Navajo weaver, Katie Henio wants to use as little store-bought dye as possible. She is proud to use in her rugs the natural black wool of her sheep, the grays and browns and the creamy white. They look strong and beautiful. For other colors she makes her own vegetal dyes from plants, lichen, nuts, and bark she gathers nearby. She brews them in boiling water over open fires and steeps her white wool in the liquid—always trying to dye at least enough wool at one time to complete one whole rug on her loom.

She gets her pink from ripe cactus fruit; red from chips of Brazilwood; reddish-orange from lichen; brown from walnut shells; gold from walnut

18

leaves; yellow from juniper berries, or from wild carrot, rabbitbrush, mustard flower, coneflower, or snakeweed; blue from a dye, made from the indigo plant. In order to have green she dips blue wool in yellow dye made from snakeweed.

Colors depend on how strong the dye is and how long the wool is left in it and on whether the plants were gathered in spring or in fall.

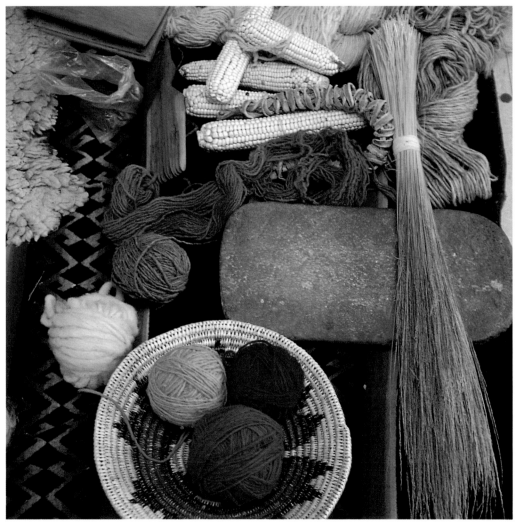

Still life shows a Katie Henio wedding basket (up front) and wools in the natural whites and the grays from her sheep. The red and this brown have been dyed, though some brown comes from her sheep. The finer, thinner wool has had two or three spinnings, the coarser wool, one.

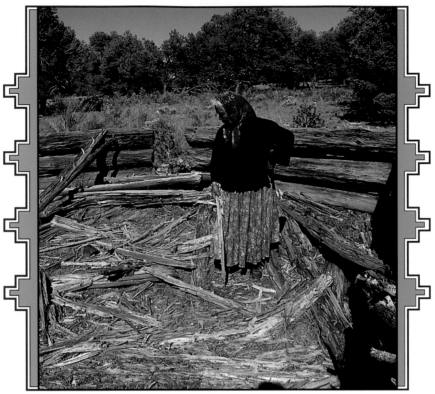

Katie Henio at the ruin of the hogan where she was born looks to the very spot where her mother told her the birth took place.

"NOW I WISH I'D GONE TO SCHOOL"

To get to Katie Henio's hogan where she was born is fifteen miles over a road that's a pair of dirt tracks. It leads past grazing lands she has used since she was a girl, past where she camped this March during the lambing season, past the clump of pines where, as an eight-year-old, she got her first porcupine. In those days, before she had her gun, she shot it with an arrow.

For years now, the hogan that was home to her as the youngest of seven

20

children stands as a lone structure in all the openness. It's a ruin of pine logs, silvery with age, built up on six sides and open to the elements. The doorway is open too. Of course, it faces east to receive the blessings of the sun. And the floor is bare earth, as it was then, though then a fire burned in the center, sending up smoke through a hole in the log-and-dirt roof.

When Katie Henio enters the airy ruin, she can point to the very spot of earth where her mother told her she was born. "Here," she says. "It was January, snowing, when I was born. Of course, the logs were chinked then with clay and dried grass. A hogan with many bodies in it and a fire burning is snug and warm. Every visitor who entered knew to move sunwise—to turn to the south first, then to cross in back of the fire, west and north, before leaving.

"Where it's all scrub brush now, out to the east, we had our garden—

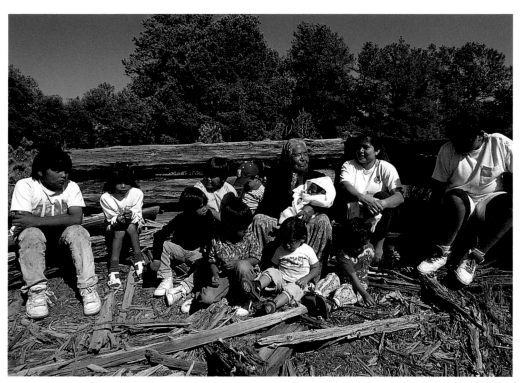

Katie Henio is happy to have her family picture taken at her old hogan. The children who have been using the ruin as a kind of jungle gym settle down on the logs around her.

21

our pumpkins and squash, corn, beans, potatoes. The sheep corrals were to the north. My parents buried the umbilical cord from my birth out there, in the corral—to show their wish for me that sheep would be the center of my life.

"I was always out among the sheep. My mother took me, and it was always interesting to me—the sheep and the birds, too, and the plants, the clouds. She'd leave me while she went to prepare food or to finish weaving a rug. My family had three thousand sheep then, and by the time I was eight, I had a flock in my care. I loved the sheep and I'd nap out there among them. They didn't leave me. If I lost a sheep I was whipped. I'd lost wool and our food.

"Some time my mother saw I'd tried to work at her loom. That's when she attached a little frame to the back legs of a wood chair. So then I had a loom of my own where I could work too.

"I'm still at my loom, but now I wish I'd gone to school," says Katie Henio. "I'd speak two languages, and I think if I'd gone to school I'd be a teacher." The lines by Katie Henio's eyes deepen. And her eyes narrow. Then comes the laugh. "I'd be a professor, wouldn't I?

"But when the white people came to the hogan to take me to school, I wasn't there. My parents had told me to run far and hide and not to come back until I saw they'd gone.

"School would have taken me away, because then the government had boarding schools for us. And the Navajo boys and girls had to speak English only. They were punished if they spoke Navajo, even to each other. My parents didn't know what the outcome would be. If I left them I might become different. They wouldn't let me go. They were not willing to trust.

"My parents told me the sheep would be my life and my livelihood. They'd be my food and give wool for my rugs. They'd take care of me and of my children.

"Now sheep have been to me everything my parents said. And more."

All the same, Katie Henio believes strongly in school. When her children were young, she and her husband moved near town in order to be close to school. And all her ten children are well-educated, using their educations to be tribal leaders and planners, police, teachers, builders.

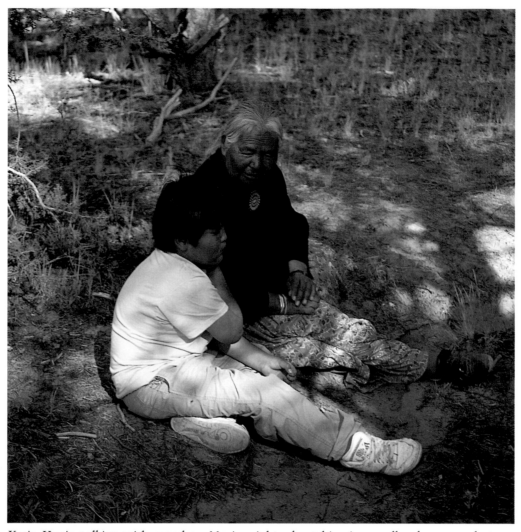

Katie Henio talking with grandson Mario, eight, about his pine needles, bones, and stones found in the woods at Narrow Canyon—her favorite woods anywhere and a special place where she digs her plants.

Katie Henio tells Navajo boys and girls to study well and always to remember their people. "Look back and try to understand, so the past will not leave scars. The past will live as part of you."

The past lives with Katie Henio in the pattern of her life. She feels it —strong and healing—when she sits at her loom in the shade house. Grandchildren Rhoda and Mario have taken over with the sheep. She asked them

to and they said, *Hágo shį́į́*, meaning, "Okay." Her narrow sash loom is propped against a shade-house post.

She will weave some inches of the bright sash before she goes to help with the animals. Her mind is clear as she weaves. She counts the threads out loud—one white, eight red, nine times white and red. The sun through the branches above casts stripes of light and shade on her.

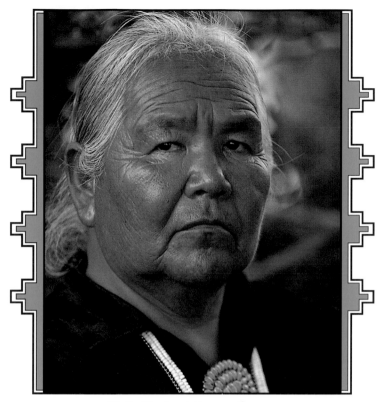

Katie Henio at Narrow Canyon

CUSTOMS TO KEEP

NAMES

To every child born into the family, Katie Henio gives a Navajo name. But the name is secret and sacred—to be thought of, proudly. "If you tell your Navajo name to strangers," she scolds, "your legs may go hard." And so the boys and girls are known to each other and to the world with everyday names such as Sharon and Celeste, John-John, Patrick, Mario. She became Katie when she was thirteen, in the hospital with a bad case of chicken pox. "The nurses said I looked like a Katie to them. That's what they named me, and I liked it."

UMBILICAL CORDS

Over the years it is Katie Henio who saves a newborn child's umbilical cord and puts it in a special place, just as her parents buried hers in the corral. "You try to put it somewhere that will be important in a child's future—in a cornfield, if you hope the child will become a serious gardener, or under a loom for a future weaver." Katie Henio has buried one in the hogan, several in the corral, others in the cornfield. Grandson Neil's got hung on the gunrack of his parents' house. Neil is still too young to hunt, but the cousins notice he loves to follow animals. Deer and wild turkey—he always watches them.

SALT

A block of salt is ready for when the newest great-grandchild laughs. The person who wins the first laugh from the baby gives a feast and helps the baby to hand out presents, including the salt, to everyone. The salt is special, because it is gathered from the salt lake nearby that has always been sacred to Navajos, though only males may go there.

COMING-OF-AGE CEREMONY

Katie Henio helps a granddaughter prepare for her coming-of-age ceremony. She brushes the girl's hair with a tall brush made of stalks of wild wheat. The girl will wear her hair loose through the four days of the ceremony, and she will run toward the east with the grown-ups of her family running behind her to show their support and respect for her. Katie Henio also helps the girl to sprout wheat for use in the huge ceremonial cake. The cake, mostly cornmeal, is baked underground all night in cornhusks, and it sends up puffs of steam when the ground is opened in the morning. Guests feast on the cake and carry home chunks of it in flour sacks and boxes. Only the young girl may not have a piece, not even a taste.

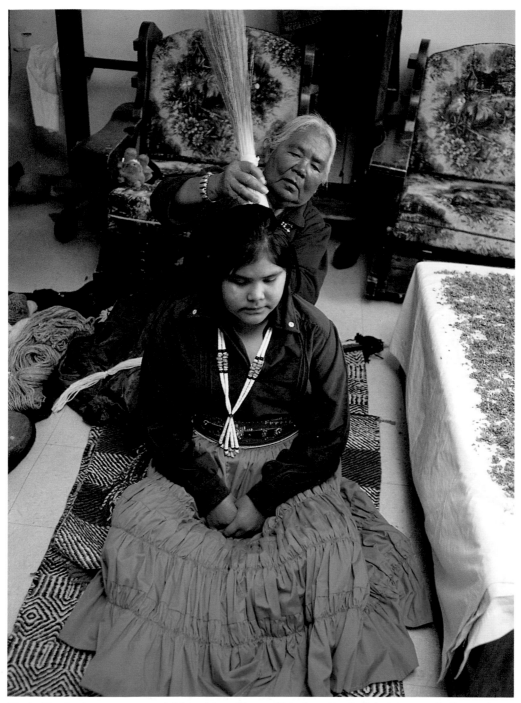

Katie Henio does a ceremonial brushing of granddaughter Rochelle's hair. Rochelle, twelve, is about to celebrate her four-day coming-of-age ceremony.

WEDDING PUDDING

It's Katie Henio's privilege to make the pudding for a family wedding. Basically, it is blue cornmeal and juniper ash, simmered in water—a blue mush into which she sprinkles white, yellow, blue, and red corn. At the wedding, she sprinkles corn pollen in a pattern—from east to west, then south to north, and all around the rim, clockwise. The groom scoops mush out of the wedding basket with his hand and eats it. The bride does the same. They start at the east side of the basket, then scoop from the south, west, north.

WEDDING BASKET

For a granddaughter, Katie Henio is weaving a wedding basket of split sumac stems. Until it's finished, she keeps it hidden in cloth. She'll only say she's weaving strong Navajo symbols into it—to represent the four sacred mountains and the rainbow that surrounds them, and the twelve holy people too. Close to the rim her designs will represent "the five-fingered people," a name by which Navajos call themselves.

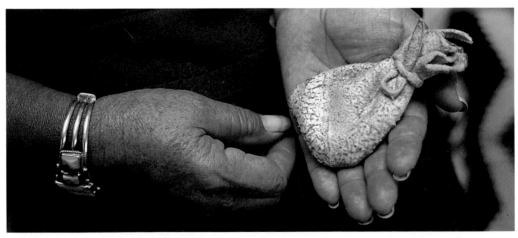

Pollen bag. The bag is deerskin and must be made from an animal that has not been killed with bullet or arrow. The bag is stitched with rawhide thread in the presence of a medicine man who sings a blessing on it. He also fills it for the first time with pollen shaken early in the morning from corn that's beginning to form its tassle. "Corn represents us—the Navajo people—our strength, our kinship, our growth."

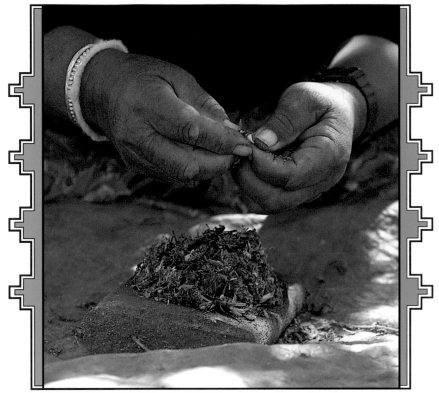

In the shade house, Katie Henio crushing plants to prepare the mushy green poultice for her son Jonathan's wrenched knee

"PLANTS CALL ME"

Katie Henio has a sense for where the plants are. They're like people, she says, and have their own clans and their own territories. "The plants call me and let me know where they are and how I can use them for my medicines and my dyes." For each plant that she digs she has a reason, and she makes it her practice to leave enough roots for the plant to grow again. From a little pouch at her waist she sprinkles corn pollen before she digs. "Corn is our greatest wealth. And so I give it as a gift— to the plant, to Mother Earth—saying a little prayer."

On a June day a patch of wild bean plants growing from a steep bed of rocky rubble calls Katie Henio to the eastern slope of Flat Top Mountain.

29

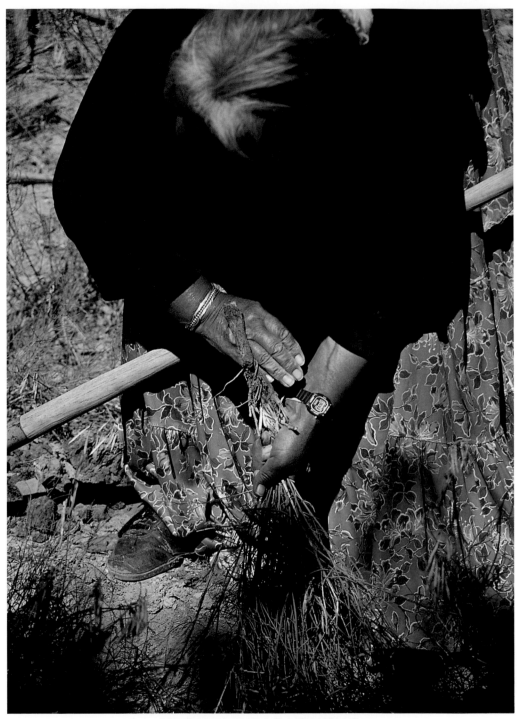

Studying the roots, "reading them"

With her first cut into a root, she thinks about her granddaughter who has just given birth. She "reads" the tinges of red in the pale root, and she understands: the young mother is still fragile. A drink made from the plant—roots, stems, leaves—will help to give Sharon new strength.

Slender-leaved Navajo tea plants call Katie Henio to Narrow Canyon. She'll add them to the brew from the bean plants. And she fills a kerchief, too, with the fuzzy leaves of hunter's tobacco for her son Nathaniel. He'll dry the leaves and grind them and roll them in a cornhusk for a smoke before he goes on a hunt. "The smoke is to take away his human odor so the animals won't sense his presence."

Owl's-claw plants, with their little bird-claw roots, grow just about everywhere Katie Henio goes. Out herding, she climbs down often from

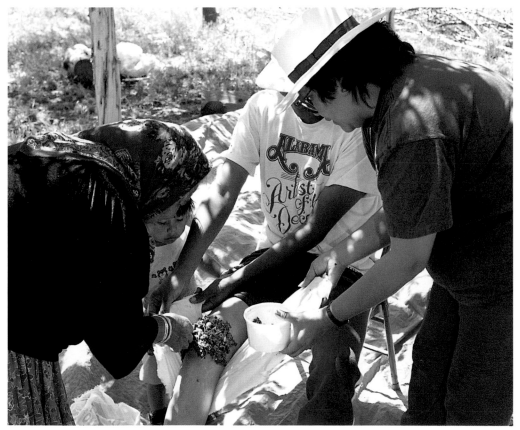

Applying the poultice to the painful knee and wrapping the medication securely in place

31

her horse to gather them for use as a medicine. With her stones she grinds the plants—roots, stems, leaves. She grinds a kind of morning glory, too, plus a plant she calls the bitter-tasting plant. When her son Jonathan is hurt, thrown from a horse at a rodeo, she applies the runny green paste from the plants to Jonathan's right knee and holds it in place with a wrapping. She says the wrenched knee will stop hurting and start tingling.

From the common yucca plant, knobby roots the size of baseballs are a gift of soap from Mother Earth. The roots need to be peeled of their brown bark and crushed. Then, frothed up in water, they make Katie Henio's best soap for washing her wool, just as it comes from the sheep. If grandson Dwayne is hanging around, he begs a yucca-root hairwash off his grandmother. He shakes away the drops and says he feels new energy.

In the woods and along roads, juniper trees are fragrant and plentiful, but they fail to interest Katie Henio until the branches show a tinge of

Katie Henio lets juniper branches burn, then shakes off the ash into the pan and sifts it.

32

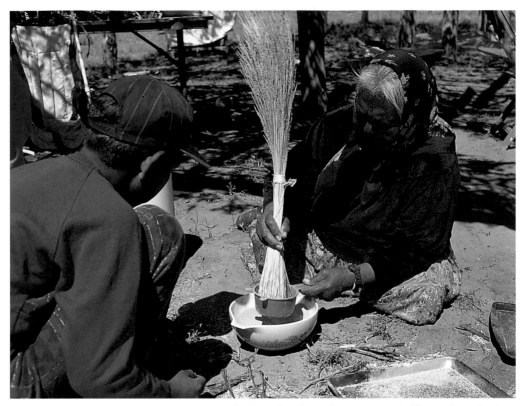

With grandson Dwayne watching, she sifts the ashes from the juniper. She'll use the ash along with cornmeal in breads, cakes, mush. She will also use it in yellow dyes.

pale yellow at the tips. When they do, they're just right for her. She advances on the tree, arms swinging, and wrenches off branches, as big a load of them as she can lift. She needs them for making the juniper ash to be used in dyes and in cooking. The ash is an essential ingredient in kneeldown cornbread, in ceremonial cornmeal cakes, and in mush.

To get the ash, Katie Henio, on a not-too-windy day, starts up a fast cedar-wood fire at the shade house. Onto the fire she throws the juniper branches, knowing they will smolder rather than burst into flames. And when the woody part of the juniper looks red hot, she lifts out the branches, one by one, and shakes their ashes onto a flat pan.

The next step is to sift the ashes. They're powdery and pale silver in color. Her great armload of branches will fill one coffee can with the precious ash.

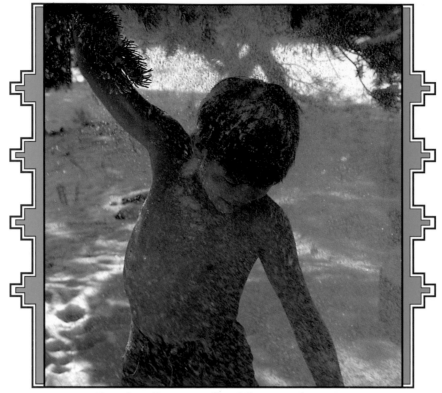
Grandson Dwayne yells while snow showering.

GRANDMA STORIES
BY DWAYNE

Sixth-grader Dwayne, twelve, knows how to ride steers. He breaks bulls in junior rodeos and goes on hunting trips with his uncles. He makes kneeldown cornbread, cooked in husks, underground. From his grandmother he knows the sheepherding life well. He can take over for her with her animals. Dwayne talks Navajo well too. She taught him. And he likes translating for her, also tattling on her. "Grandma stories? I have lots."
. . . "Grandma's a great shot with her .22. She's the one who keeps away the coyotes. I've seen it. Once I was with her when some coyotes rushed in and chased her sheep. She was after them and she got right up alongside.

34

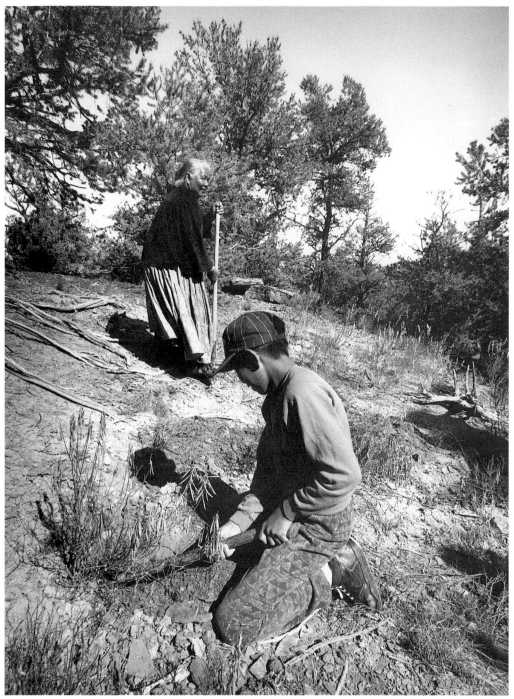

Katie Henio and grandson Dwayne digging wild bean plants on a stony slope of Flat Top Mountain

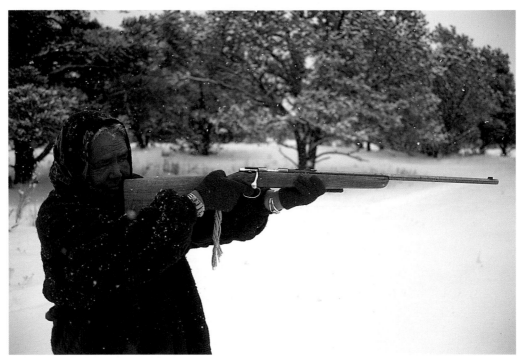

Katie Henio shoots to get food and to protect her sheep from coyotes.

Her horse was a roping horse, so it knew to stay close. And she leaned out and whacked at the coyotes with her stick. She whacked one dead right in its tracks. Those coyotes were crying all the way into the woods. That time she didn't even need her rifle.''

. . . "When I was little it was scary. Me and my cousin, we slept out and watched the sheep with her. When some coyotes came along, we went under the covers. But Grandma grabbed her gun and charged after them, shouting. It was awful, but coyotes get right through a gate into a corral. In a bad year, she's lost twenty-five sheep to them.''

. . . "If there's danger, Grandma's with her animals all night, or if a new lamb gets in trouble breathing and needs her to flip it on its side, or if a mother doesn't take to a lamb right off, she stays with them. She won't let an owl near her lambs.''

. . . "Two sheep died at sheep camp from rattlesnake bites. And then a rattler was racing toward the corral. I saw it. And Grandma got it with a rock to its head.''

. . . "Everybody knows Grandma's a good heeler and a good header—great with a rope. She tells you before she throws. She's going for her sheep's head, she's going for its heel. And that's what she gets."

. . . "Lately Grandma's horse bucks her off. People don't know that. She doesn't like to talk about it, but I've seen it. Dakota just bucks her off sideways. No warning. I think he gets bored and doesn't want to herd sheep. At least Dakota doesn't leave her. He doesn't even move. Dakota just waits for her to get on again."

. . . "And all her stuff about plants. Sometimes I help her dig. And when she needs a new shepherd's stick, she cuts down a young oak tree that's straight and not too big around. She gets me to shorten it so it's just as high as her collarbone and to trim off the bark. She'll use it to nudge along some lost lamb toward its mother. Or she'll use it—so she doesn't have to get down off her horse—to help a lamb out of a ditch. Or she'll whack a rattler with it. You should see her swing it around her head. She says in the city she'll whack a thief with it."

. . . "Grandma knows a lot of little things, like—if you sneeze, someone's thinking of you. If you see a whirlwind, tell it your in-laws have come for a visit, and then it won't carry your things away. She says, spit at a tornado!"

. . . "I guess all of us learned from her about morning runs, running toward the east at first light. The best is in winter when you run and throw off your shirt and you shake snow down on your bare chest from the branches. It makes you yell from the shock of it, *'YAY HOO'* and *'O-ch, O-ch, O-ch!'* Grandma says to yell: 'Pay attention to me, a child of Mother Earth!' It feels good. Grandma understands about yells."

. . . "Now that she taught me how, I make kneeldown cornbread. It's called kneeldown because you grind the corn on the ground—on a stone. You put the ground corn in the middle of a flat long fresh cornhusk and fold it together. Don't tie it. It has a lot of juice. You put the husks, standing up, in a bowl. Then you keep a fire going in a pit for an hour and put the bowl in the pit. Cover it and pile dirt on it. It heats for an hour and a half and it's done. I got an award for it at 4-H."

ADVICE TO GRANDCHILDREN
FOR TAKING OVER WITH
THE SHEEP

Of course, look out for coyotes.

You have a lot of loose time, but keep alert.
The sheep look like they're still, but they can move fast.

Be sure sheep are not eating in a patch of yellow owl's-claw.

At the water hole be sure every animal drinks.

Count the flock when the animals go through a gate—136,
137, 138—or when they're lying down for a rest.
It helps to count an odd-colored one first,
then count the others nearby.

Going past woods, watch it!
Goats slip away, but at least they come back again.
Sheep go into the woods and they keep going.
They're gone for 20–25 miles.
You might never find them.

Remember not to drive the animals too far.
You need to bring them home before sundown.

Check all around the corral before you leave them.
Check for holes in the fence.

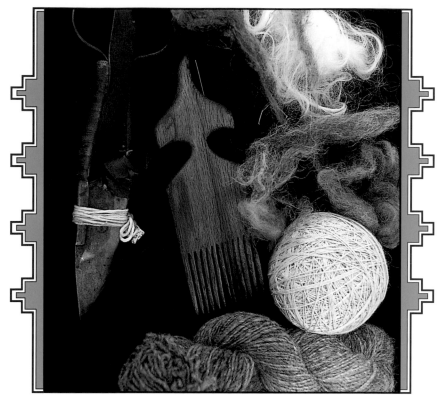

Wooden batten comb is a favorite tool.

TOOLS

"I have my own tools and they are precious to me," says Katie Henio. "They mean I'll never be poor." She has always loved her own good tools, but she is thinking about tools a lot because of the amazing invitation. She is invited to Washington, D.C., to set up a little sheep camp on the grassy Mall. And she must think what to take with her for showing off the life of a Navajo herder of sheep.

Not her sheep, she can't bring them, though there will be churro sheep from nearby for her to shear in front of everyone. Not her horse. She can't have him with her or her dogs either. But a truck is hers to fill. And she can bring along her large looms and the cookpots, for cooking up her dyes,

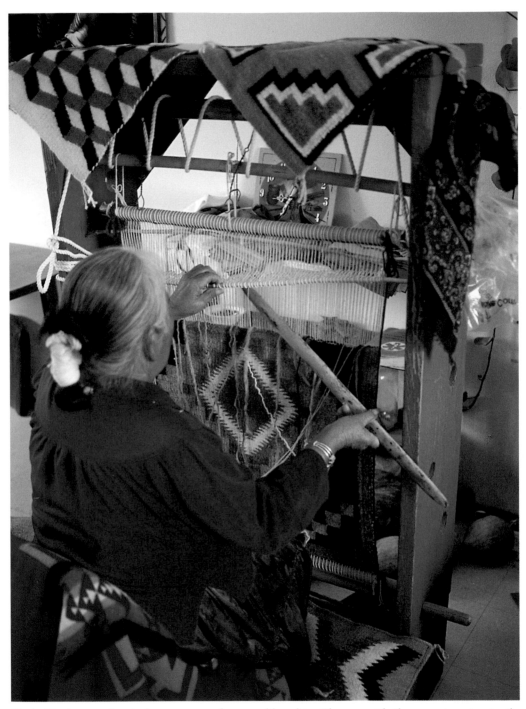

Katie Henio weaving indoors—a rug for granddaughter Sharon with the morning star in the center and the mountains along the edges

even great cedar logs to serve as the posts for her shade house. Branches cut in Washington will have to do for the roof of the shade house. Piled up in a circle, they'll have to do, too, for the fences of her brush corral.

Her head is filled with lists. She will take: her loom, the big upright loom for which the Navajos are famous. It's strong and can be moved about and set outdoors in good weather. A rug is woven on it from the bottom up.

She will take: her batten comb, made of wood, with teeth to fit around the up-and-down warp threads on the loom. She uses it while she weaves—to tamp down the new rows snugly.

She'll take: her sash loom too, for weaving bright ceremonial belts. Years ago her husband made it from a tree where the trunk separates to form a *V*. She likes to think of his hands, making it for her. A friend made her the batten for this smaller loom, again for banging down the new rows of weaving. This batten looks like a knife, out of sumac wood, and it's carved almost to a knife edge too.

She'll take:

Carding combs, her wooden paddles with rows of short, needle-sharp points sticking out of one side. Katie Henio holds a paddle in each hand and draws them across each other several times in order to card, or comb, the handful of wool fluff placed between them. Carding gets the fibers in the wool going in one direction. It creates neat little pads of wool that she can stretch out and join together to make a kind of loose rope ready for spinning.

Her spindle, the typical Navajo drop spindle. It's her favorite tool. Pretty as a toy top, with its whorl at the bottom and its long slender shaft, she likes to have it with her always, at home and out on the range, tied at the front of her saddle. (She has to hope her horse, Dakota, doesn't roll in the grass and splinter it, as he's been known to do.) Katie Henio sets the spindle in motion with her right hand, rolling its shaft against her thigh; with her left hand she feeds it the wool. Then she uses both hands to stretch, twist, pull the wool, trying always for an even thickness and as few lumps as possible.

The big knife. It too goes everywhere with her, in the cloth bag tied to

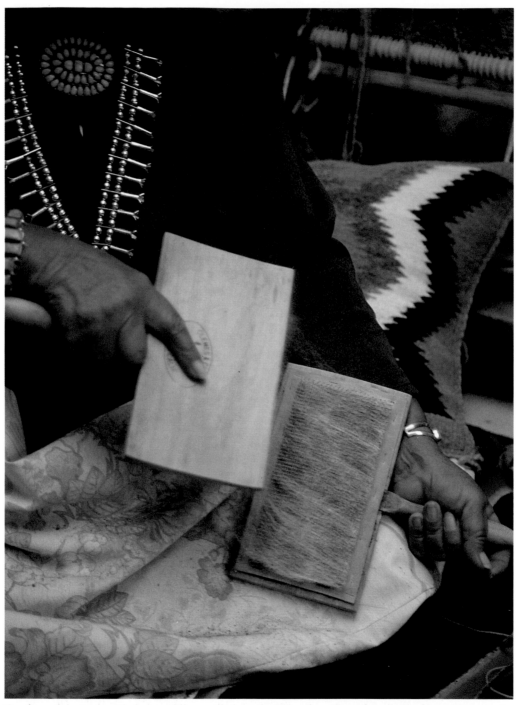

Carding the wool with her paddles, called carding combs—"combing" the fibers. This is the first step after washing the wool as it comes off the sheep.

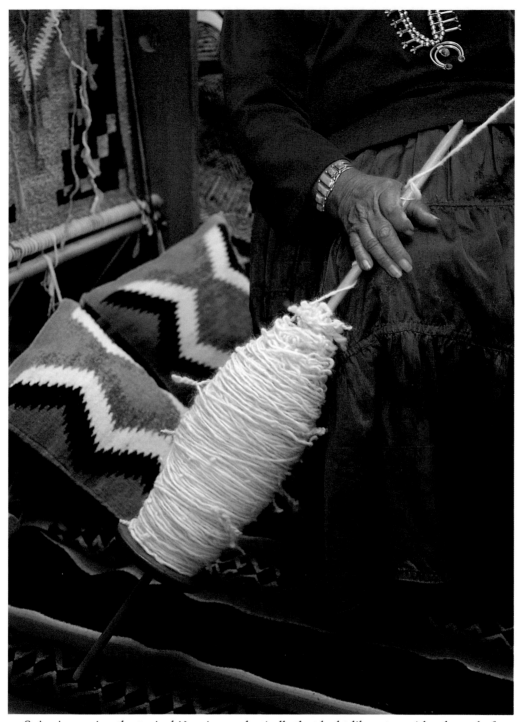

Spinning, using the typical Navajo wood spindle that looks like a top with a long shaft

her saddle. The knife is sharp and in her hand it has a good balance. She uses it for many things and always for butchering—a job she's proud to do well. Her family thinks meat tastes best when it's her work.

In the truck to Washington she will send her frybread turner, which is a long, peeled cedar stick; and her greasewood stirring stick, for making puddings; and her shepherd's stick, newly cut from an oak sapling; and the long slender firepoker she uses to lift juniper branches on and off the fire when she's making the ash to mix into her mush and her breads.

She will pack the whisk used in sifting the ash. She makes it from hundreds of tall grass stalks gathered in fall in the mountain woods. She'll pack her basketmaking materials too: the split sumac stems, the pan and sponge for keeping the stems wet, the ice pick stuck for safety into a corncob.

Blue corn also and her mother's grinding stones on which she grinds it. The beloved clippers for shearing, a tool to be cherished. She can depend on the sharp blades to make the hard work of sheep haircuts a pleasure.

Her tools will tell a story even if she is silent.

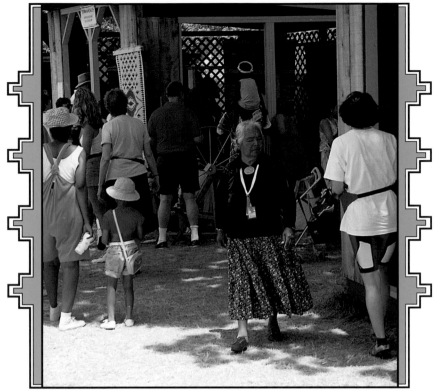

Katie Henio in Washington

ON THE MALL

When she's on the Mall in Washington, D.C., standing in a small flock of running, high-jumping sheep, Katie Henio swings her rope and rings the one she intends to shear. Her son Sam talks to the crowd as she applies her favorite old shears to the coat of a stranger animal. She talks softly to the sheep in her own language.

Sam Henio, telling about her sheep at home, her plants, her spinning, and her weaving, says, "My mother never has nothing to do, even in the dead of winter when the snow is deep and the animals are penned up close to home. She always has projects, but my mother never rushes either," he says. "She stays calm. Navajos have all the time."

Sam brags some, too, telling how Katie Henio serves her community

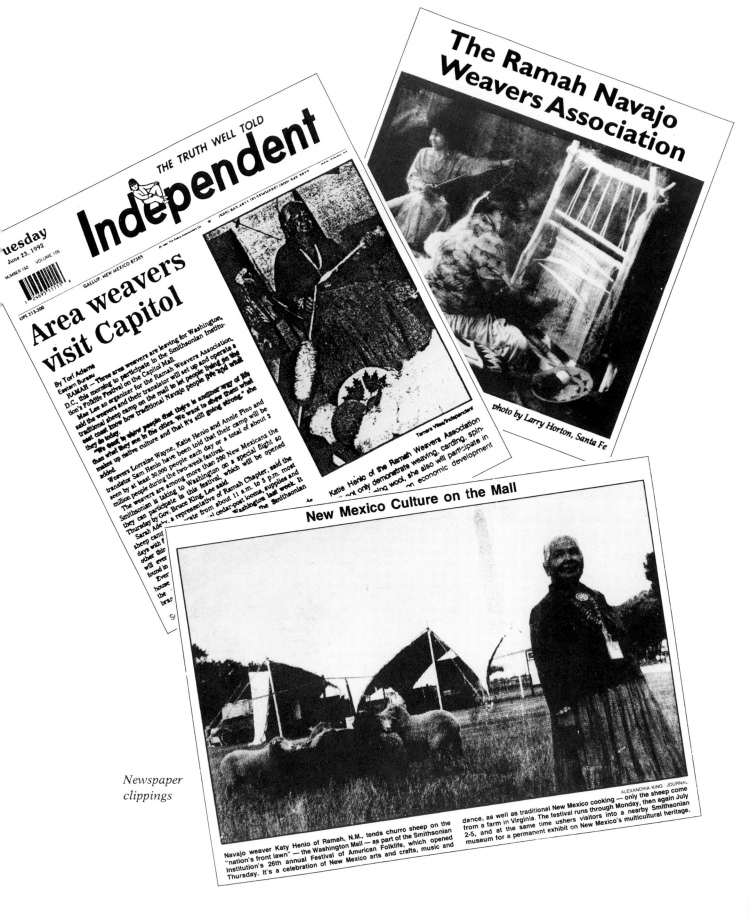

Newspaper clippings

as a peacemaker, assigned by the courts to talk with troubled families and help them to solve problems and reach understandings.

She also belongs to a co-op, the Ramah Navajo Weavers Association. With friends who live her same life—as sheepherders and weavers—she works for healthy flocks and for ever better wool and fine rugs. The money they make comes from selling wool and selling the rugs they weave. Will they be able to show the harmony of a life on the land with sheep and a loom to weave on? Sam tells how his mother hopes so. Then young people on the reservation may choose the life for themselves. And so may their children and their children's children.

On Washington's lawn, the crowds amaze Katie Henio. At home she goes for weeks scarcely seeing even members of her family. Here, the thousands of people are a new experience. Some give her quick glances. Others stay to watch for hours and they return for days in a row.

Children—and parents too—at her knees, practice sitting like a Navajo, on the ground on one foot that's tucked under. They ask about her Navajo hairdo, the ponytail that's flipped up and wrapped in place with heavy thread. They ask about the Navajo skirt—always full and long, in pioneer-woman fashion. At a folk festival such as this, people are invited to touch her wool and her tools and to touch a finished rug—hairy and rough—a sign that it was made from churro wool.

People finger the wool straight from the sheep, then the washed wool, and the soft puffs of it after it's carded. They hold the ball of wool that's been spun once, then the thinner, stronger wool from second and third spinnings.

They watch Katie Henio at her loom ripping out a bad row with a large needle. Her fingers weave it again, then bang down the batten comb to settle the new row in place.

Many people ask: Does she weave by patterns? Sam replies no, that "Navajo weavers see a design in their heads. They start in weaving then watch where it leads them, changing along the way." Sam says that "stripes at the edge of a rug are often rainbows, a diamond may be a star, jagged zigzags may refer to lightning, which is a protector, driving away evil spirits."

When Katie Henio is asked about the rug on her loom, she answers through Sam, "It will have mountains at the sides and in the center a hailstorm. Many images with moisture are woman images," she says. "They have to do with healing and nourishment—a healing rain."

Washington in summer is hot in a way it is not hot in her high country at home. It's humid. And Katie Henio is glad for her full skirt. She mops her wet brow with a corner of it. She's glad for all the attention, too, from the public. It makes her proud.

Nights, though, at the hotel, she is uneasy about her sheep at home. She misses them. She worries when she hears by phone that Burnt Woman slipped away from the flock, leading twenty-five other sheep with her, and that it took a day to find them. Two were killed by coyotes. She worries even when she hears that all is well again and that her dog Ma'ii is waiting for her by the door, and that an invitation has come for her to visit with sheepherders in Australia.

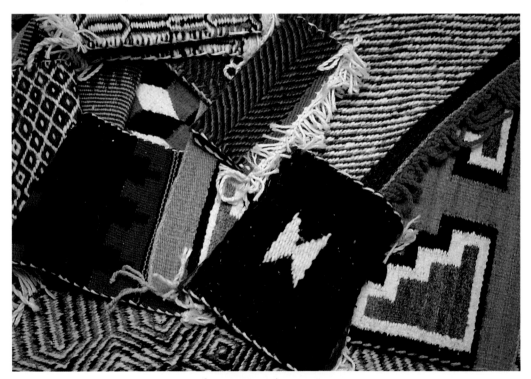

Some of Katie Henio's weaving patterns

48

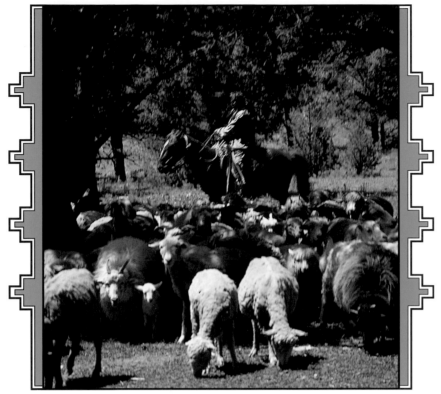

Sheep grazing in home woods

AND BACK

Two million new people in two weeks at the folk festival—they've floated past her eyes. And some have become friends. But the joy of it is to be home again and out at camp with her horse hobbled nearby and her dogs guarding the sheep in the brush corral, and a supper on the fire. If the dogs don't run off howling with the coyotes, she'll sleep a long peaceful sleep in old familiar blankets. A tumult of sheep will come trampling out to the grass, bawling, when she opens their gate at first light.

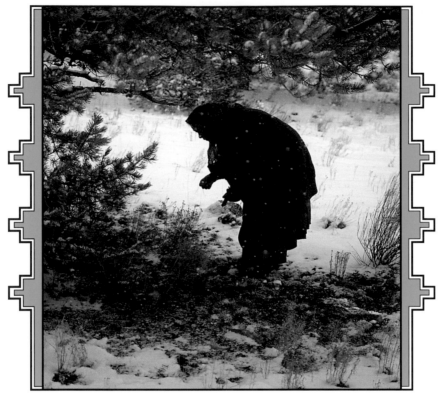

*Early snow—searching under the pine trees
for piñon nuts*

WELCOME, WINTER!

For Katie Henio living out at her sheep camps, life is happily full; even through the first snows, her animals find grass, bushes, and low branches to feed on. In the harshest weeks of winter, when the snow is deep, Katie Henio moves to her house and settles her flock into the corral beside it. In the corral, sheep are safe and she can set out grain in the trough and fresh hay for bedding. She can treat them for coughs. On the loom by her bed, she'll weave a new rug from the pattern that's building in her head.

Her family—children, grandchildren, great-grandchildren—are glad to have her back. There is a new baby to welcome, and ceremonies to cele-

brate, boys and girls to talk to. Katie knows the children watch too much television and never hear enough Navajo.

Her sons and daughters tease her: it's her own fault. She's too often away from them, she loves her sheep and her sheep-camp life too much. They say they worry about her, too, when she's out with storms and rattlers. She should sell her animals, they say, live at home in a warm place and pay her utility bills.

She teases back. "Do you want me to get arthritis and run up medical bills?" It's true, Katie Henio is sad to leave her sheep even for a day. Her grandchildren have it figured out: if her sheep are sold, Grandma will run away to where there's a flock for her. Katie Henio doesn't say yes, doesn't say no. "I have what I grew up with," she says. "I live it. Tending sheep is my skill."

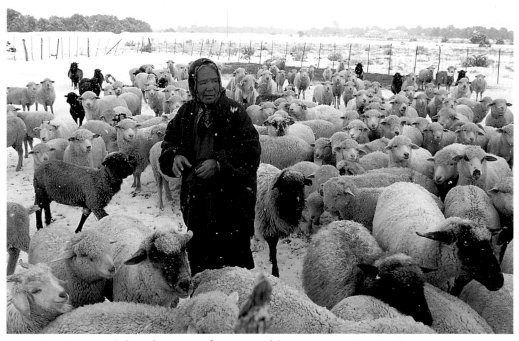

In winter with her sheep crowding around her—Navajo sheepherder Katie Henio

.